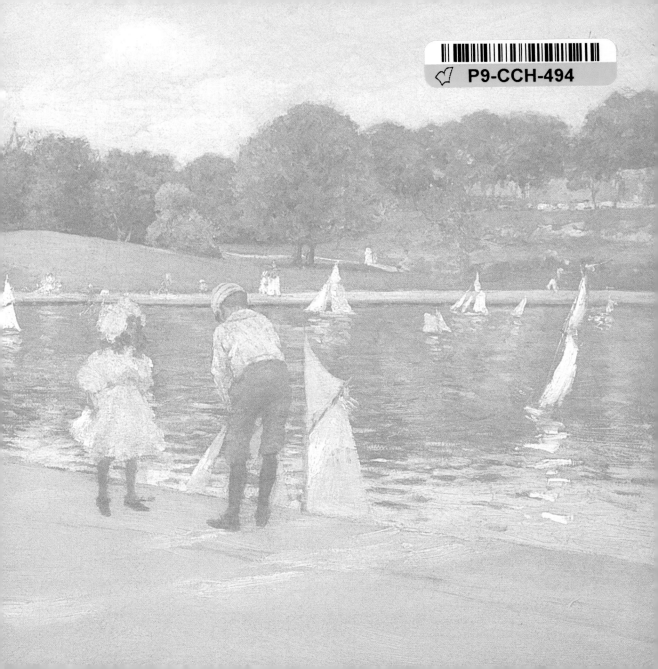

The Gilded Age

EDITH WHARTON
AND HER CONTEMPORARIES

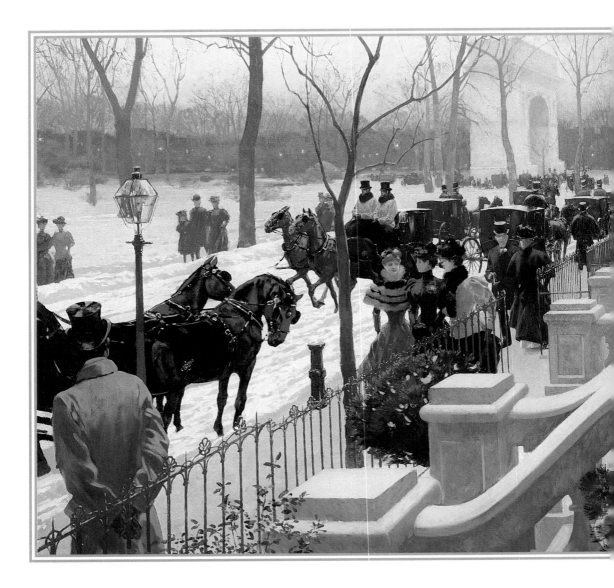

The Gilded Age

EDITH WHARTON
AND HER CONTEMPORARIES

ELEANOR DWIGHT

UNIVERSE PUBLISHING

For my mother
Eleanor Morris Collier,
with love

Acknowledgments

I would like to thank friends and colleagues who read my
manuscript: Candida Dixon, Gigi Wilmers, Viola Winner
and Adeline Tintner, as well as my editor Sandra Gilbert,
and of course, my husband, George Dwight.

FRONT COVER:
John Singer Sargent
In the Luxembourg Gardens

BACK COVER:
Frederick Childe Hassam
Columbian Exposition, Chicago

FRONTISPIECE:
Fernand Lungren
Washington Square North, New York City

First published in the United States of America in 1996
by UNIVERSE PUBLISHING
A Division of Rizzoli International Publications, Inc.
300 Park Avenue South
New York, NY 10010

96 97 98 99 / 10 9 8 7 6 5 4 3 2 1

Library of Congress Catalog Card Number: 95–62021

Design and typography by Nai Y. Chang

Printed in Singapore

Contents

• • •

MAURICE BRAZIL PRENDERGAST
The Mall, Central Park

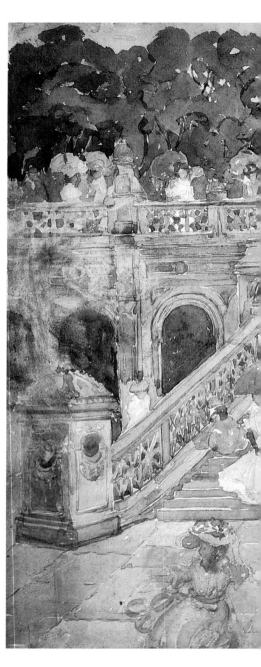

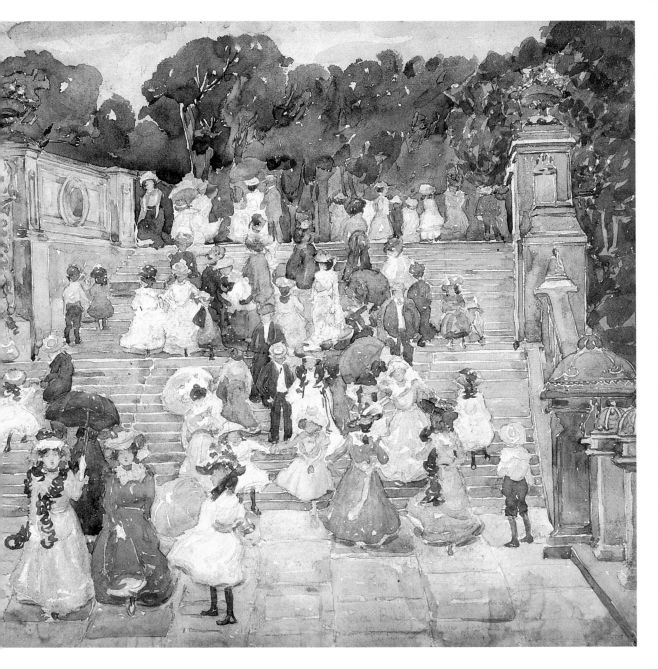

I

Introduction

❖ ❖ ❖

When Henry James was staying with Edith Wharton at her apartment in Paris in the first decade of this century, he remarked to a friend: "If every day I have but one hour in which to squeeze the sponge of the past, I am content." Both writers shared the need to feed upon the past. As our century draws to a close, we too may have this need. Perhaps the vanished time James and Wharton wrote about can offer parallels for our time.

Reminders of the Gilded Age, the post-Civil War years from the 1870s to the early years of the twentieth century, are continually emerging in our cultural landscape. Museums have recently organized exhibitions of works by American Impressionists and other artists who were active at the end of the nineteenth century. The paintings of these artists are appealing because of their rich visual details—scenes of crowds in city parks, portraits of the privileged and beautifully dressed. Movies based on Edith Wharton's novels *The Age of Innocence* and *The Buccaneers* capture the opulence of that time. The novels of Henry James continue to inspire contemporary readers and writers one hundred and fifty years after his death. The discovery of a lost Mark Twain manuscript of *Huckleberry Finn* garners instant media attention. Visitors flock to the carefully restored mansions and gardens of the robber barons.

The current interest in this period suggests a reaction against modernism and postmodernism and an uneasiness about our fast-changing high-tech world. It also suggests a longing for a time when

EDWARD HARRISON MAY
Edith Jones Wharton at Nineteen

◆ ◆ ◆

Edith Wharton (1862–1937) captured
the period brilliantly—its manners, its
settings and excesses—in pictorial prose
and with ironic humor.

life seemed at once simpler, optimistic, and more elegant. Although we see these years as different, long gone, and remote, there is a contradiction—for we also recognize in them a common spirit.

In the mid 1930s, Edith Wharton lamented the rapid and disastrous changes in her world:

> *Everything that used to form the fabric of our daily life has been torn in shreds, trampled on, destroyed; and hundreds of little incidents, habits, traditions which, when I began to record my past, seemed too insignificant to set down, have acquired the historical importance of fragments of dress and furniture dug up in a Babylonian tomb. It is these fragments that I should like to assemble and make into a little memorial like the boxes formed of exotic shells which sailors used to fabricate between voyages.*

And it is this impetus, to reassemble the fragments of the past—its incidents, habits, traditions, and personalities—that has led to the making of this book, which offers a glimpse into a remarkable era.

The Gilded Age was an exciting time. After the Civil War, America was rushing to come of age in business and the arts. Enormous fortunes were being made—and then lost overnight. Gold dust seemed to rain down from the skies and new inventions were changing long-accepted patterns of living. This vanished period continues to live in the works of its perceptive writers.

It was Mark Twain who named the period in his novel *The Gilded Age*, in which he used his exuberant humor to mock the greed and self-importance of the new rich after the Civil War. Great wealth, he wrote, gave a man a still higher and nobler place than official position. If his wealth had been acquired "by conspicuous ingenuity, with just a pleasant little spice of illegality about it," all

JOHN WHITE ALEXANDER
Samuel Langhorne Clemens
(Mark Twain)

◆ ◆ ◆

Mark Twain, (1835–1910) [pen
name for Samuel Clemens],
whose great energy and appetite
for life took him all over the
country, used his sense of the
ridiculous to point up the con-
tradictions of this time.

the better. These new rich were "fast" and "not adverse to ostentation." But we owe a lot to their ostentation: the wealth they spent so freely around the end of the nineteenth century has left us a legacy in art and architecture which was derived from the culture of Europe that rich Americans tried so hard to imitate.

From his vantage point Mark Twain commented on the manners of different aspects of the age: both the cutthroat business practices and the increasing refinement in the art of living. Born in Hannibal, Missouri, he was part Midwest frontiersman, part East Coast gentleman of letters. As a young man, he piloted a Mississippi River steamboat, then during the Civil War set out for the western territories, ending up in California. His marriage in 1870 to Olivia Langdon, the daughter of a newly rich businessman with a railroad fortune, brought him East and into a family whose members were pillars of the community. In Hartford, Connecticut, he built himself a mansion and played the part of the Eastern gentleman.

Henry James, one of America's greatest novelists, was another brilliant observer of the era. Like Edith Wharton, he wrote of old-monied New Yorkers and New Englanders as well as the new rich. He recorded the dilemmas of his American characters on both sides of the Atlantic: in *Washington Square,* Catherine Sloper, a homely heiress with a passion for a heartless, handsome suitor; in *Daisy Miller,* the fresh young girl from Schenectady who shocked the American colony in Rome; and Christopher Newman, in *The American,* who tried to carry off the lovely French aristocrat Claire de Cintré, the prize of the Faubourg Saint-Germain. These characters still stand as examples of the American experience at the end of the nineteenth century.

Edith Wharton wrote about the manners of the fashionable society of New York, a world she was born into and knew well. Her

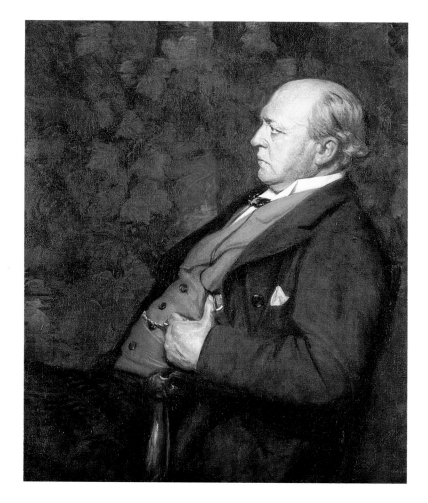

♦ ♦ ♦

Henry James (1843–1916), the observer of the American experience here and abroad, was fascinated by the social and psychological conflicts of the age.

fiction paints a picture of a time known for its genteel splendor, but also for its emptiness and materialism. She gives us a glimpse of the social rituals of well-to-do New Yorkers, descended from old Dutch

and English families, who had enjoyed social and economic prominence for generations. We see them at dinner in candlelit dining rooms where portraits of their ancestors look down from the walls. She shows us society people turned out for evenings at the opera, in carriages taking drives in Central Park, and cruising on steam yachts. She depicts the old money as well as the new rich at play. But she also exposes the reality behind the golden patina, the tarnish under the shine—the ruthlessness of the social climbing, the rigid rules that suppress real needs and aspirations, and the lack of enduring values. Her sensitive characters yearn to realize their full potential but can only become what is expected of them, like Newland Archer in *The Age of Innocence* who, looking back in middle age, realizes he has missed "the flower of life."

When Wharton first thought of writing about New York society, she felt it was "too shallow to yield anything to the most searching gaze." Her problem was "how to extract from such a subject the typical human significance which is the story-teller's reason for telling one story rather than another." She finally decided that "a frivolous society can acquire dramatic significance only through what its frivolity destroys. Its tragic implication lies in its power of debasing people and ideals. The answer, in short, was my heroine, Lily Bart." *The House of Mirth,* her first "New York novel" told brilliantly of the destruction of Lily, the beautiful but vulnerable socialite.

Looking back we can see that the spirit of the Gilded Age was also expressed in the buildings of the time. The World's Columbian Exposition, which opened in Chicago in 1893, set the stage for what was to come in the next century. Its architecture, mostly temporary structures, was a fairyland fantasy from the past inspired by Greek, Roman, and Renaissance monuments, and it firmly established the

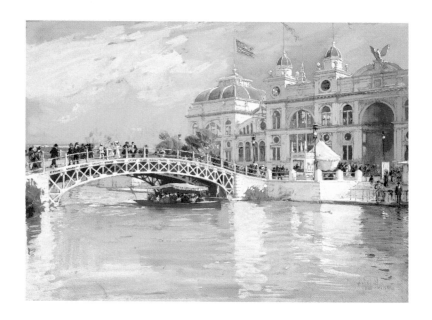

FREDERICK CHILDE HASSAM
Columbian Exposition, Chicago

Beaux Arts tradition at the expense of an original American style. It awakened people to the possibility of beautifying cities and showed the collaborative results of artists, sculptors, and architects. There was much to see and be amazed by. Young Pierre du Pont was enthralled by the fountains and would spend years relandscaping parts of his garden, Longwood, near Wilmington, to imitate the waterworks at Vaux le Vicomte and the Villa d'Este at Tivoli. Beatrix Farrand, one of our best landscape gardeners and designer of the garden at Dumbarton Oaks in Washington, D.C., was inspired by Japanese gardens. And it was at the Exposition that many visitors saw an automobile for the first time.

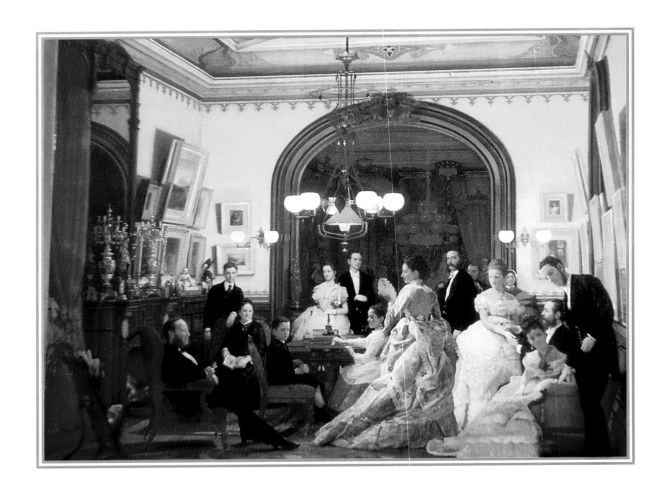

SEYMOUR GUY

Going to the Opera
[The Family of William Henry Vanderbilt]

◆ ◆ ◆

William Henry Vanderbilt, the acknowledged heir of Commodore Cornelius Vanderbilt, was painted in 1873 in the living room of his Fifth Avenue house, surrounded by his wife, Maria Kissam Vanderbilt, his sons, daughters, and sons-in-law, all turned out for the opera. A capable businessman, he oversaw the family railroads and investments, and was a patron of the arts, a collector, and a man with a passion for horses. In this painting, the details of the room suggest the comfortable atmosphere of an overstuffed Victorian drawing room and the bourgeois values of the first part of the century. Soon the Vanderbilts, with no concern for expense, would outdo all the new rich. Their goal was to duplicate, if not exceed, the scale and luxury of the European houses of noble and royal families. After his father's death in 1877, William Henry would move up Fifth Avenue to a grander mansion designed by the firm of Christian Herter. His children would also catch the building fever. William Henry's new house was said to have cost approximately 1.75 million dollars. No one in America had yet spent so much to build and furnish a home.

LUCIUS ROSSI
Portrait of the Astor Family

◆ ◆ ◆

William B. and Caroline Schermerhorn Astor sat for
a group portrait with their daughters and son. Here
is *the* Mrs. Astor, the social arbiter, who with Ward
McAllister would become legendary for creating the
Four Hundred—the list of social insiders of the peri-
od. It designated the number of guests that would fit
into the Astor ballroom. Mrs. Astor, according to
legend, only accepted the newcomer Alva Vanderbilt,
wife of William K., because her daughter, Caroline
Astor, wanted so badly to attend a Vanderbilt ball.
Mrs. Astor's salon in her house at 34th Street and
Fifth Avenue with its exquisite details, its eighteenth-
century French style, its Corinthian pilasters, and its
art collection, suggests the more aristocratic and
European look that by the end of the century was to
become the norm for many millionaires.

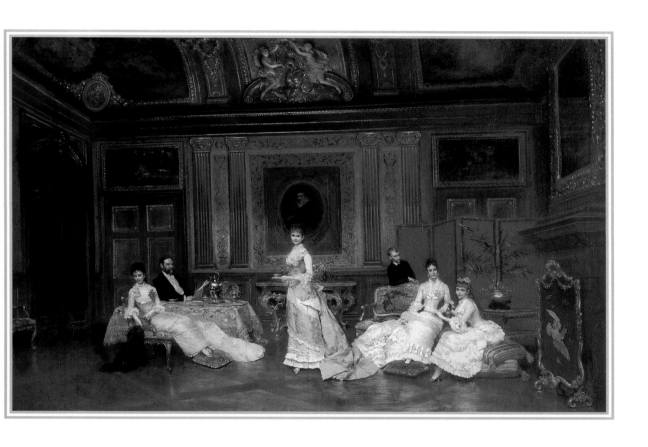

JULIUS STEWART
The Hunt Ball

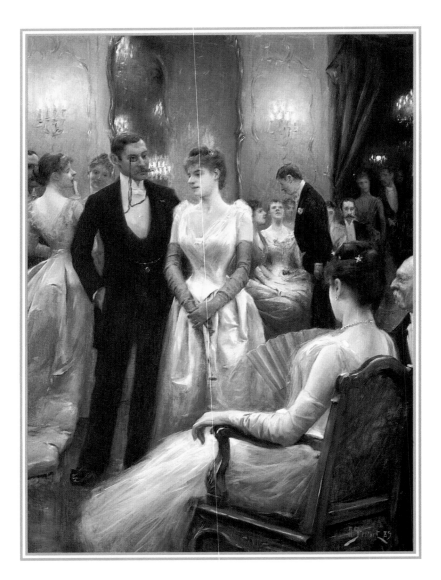

II

Palaces and Parks
New Places for a New Age

◆ ◆ ◆

*[The mansion of Julius Beaufort] was one that New Yorkers were
proud to show to foreigners, especially on the night of the annual
ball. The Beauforts had been among the first people in New York to
own their own red velvet carpet and have it rolled down the steps by
their own footmen, under their own awning, instead of hiring it with
the supper and the ballroom chairs. . . .*

*Then the house had been boldly planned with a ballroom, so
that, instead of squeezing through a narrow passage to get to it (as
at the Chiverses'), one marched solemnly down a vista of enfiladed
drawing rooms (the sea-green, the crimson and the bouton d'or),
seeing from afar the many-candled lusters reflected in the polished
parquetry, and beyond that the depths of a conservatory where
camellias and tree ferns arched their costly foliage over seats of black
and gold bamboo.*

—Edith Wharton, *The Age of Innocence*

As the Medicis had patronized
brilliant Florentine artists and architects, so wealthy Bostonians
were instrumental in the building of the magnificent Public Library,

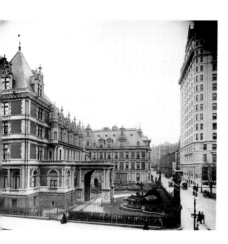

Cornelius Vanderbilt II
House, 1 West 57th
Street, 1908

a Renaissance-style palazzo with painted ceilings, statues, murals, and exquisite marbles, and bronze doors by Daniel Chester French. A collaborative achievement of native craftsmen, architects, and artisans, including Augustus Saint-Gaudens, John Singer Sargent, and Charles McKim, the library exemplifies this American Renaissance. By the end of the century, large public buildings were springing up in every city—libraries, museums, railroad stations, and universities imitating the great architectural accomplishments of Europe.

It was often the outsider who could best describe the changes. The French writer Paul Bourget arrived in America in 1892, hired by James Gordon Bennett of the *New York Herald* to report his reactions to America's progress. His book *Outre-Mer* records his astonishment. He visited New York and wrote that the "interminable succession of luxurious mansions which line Fifth Avenue" proclaim the "mad abundance" of money. The mansions "reproduce the palaces and châteaux of Europe. I recognize one French country seat of the sixteenth century; another . . . is in the style of the time of Louis XIII. The absence of unity in this architecture is a sufficient reminder that this is the country of the individual will, as the absence of gardens and trees around these sumptuous residences proves the newness of all this wealth and of the city."

Fifth Avenue, he felt, had been "willed and created by sheer force of millions." And Henry James, returning to America after an absence of twenty years, sensed the inappropriateness of Boston's library:

> But meanwhile it was strange that even so fine a conception, finely embodied, as the Public Library, magnificently superseding all others, was committed to speak to one's inner perception still more of the power of the purse and of the higher turn for business than of the old intellectual, or even of the old moral, sensibility.

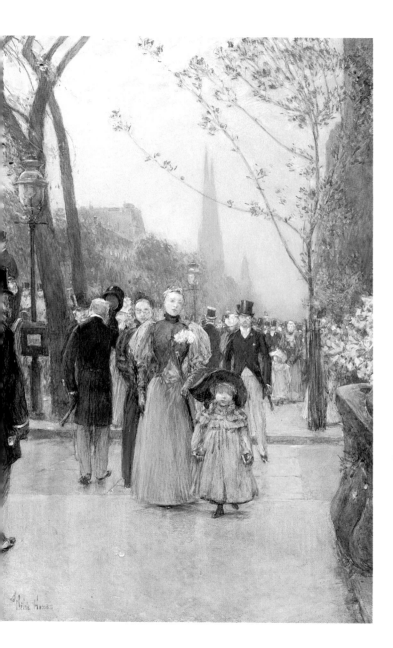

FREDERICK CHILDE HASSAM
Fifth Avenue

♦ ♦ ♦

Edith Wharton remembered the Fifth
Avenue of her childhood:

*The Fifth Avenue of that day was a
placid and uneventful thorough-fare, along
which landaus, broughams and victorias,
and more countryfied vehicles of the
"carry-all" and "surrey" type, moved up
and down at decent intervals and a deco-
rous pace. On Sundays after church the
fashionable of various denominations
paraded there on foot, in gathered satin
bonnets and tall hats.*

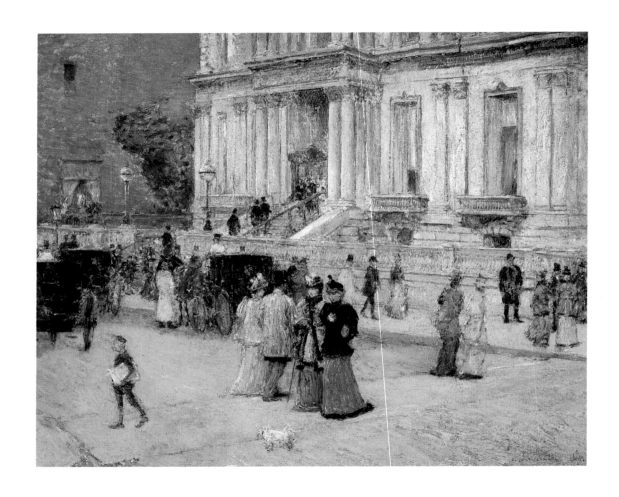

FREDERICK CHILDE HASSAM
The Manhattan Club
[also titled *The Stewart Mansion, New York City*]

In New York City, the fashionable residential neighborhoods were moving farther north up Manhattan Island. Washington Square and Gramercy Park, the bailiwicks of the well-off since early in the nineteenth century, were joined by lower and then upper Fifth Avenue as the "in" places to live. The narrow brownstone houses with their welcoming stoops were giving way to the larger, more formal mansions. In the early 1880s William K. and Alva Vanderbilt's marble château at 660 Fifth Avenue, designed by Richard Morris Hunt, was completed, and became one of many impressive architectural extravaganzas he would create for the family.

Edith Wharton described New York City as it changed between the 1870s and the early years of the new century. When she had returned from Europe at the age of ten she had been appalled at "the intolerable ugliness of New York, of its untended streets and the narrow houses so lacking in external dignity, so crammed with smug and suffocating upholstery. How could I understand that people who had seen Rome and Seville, Paris and London, could come back to live contentedly between Washington Square and Central Park?" But she would praise the new construction at the end of the century: "With the coming of the new millionaires the building of big houses had begun, in New York and in the country, bringing with it a keen interest in architecture, furniture and works of art in general."

Outdoor spaces were also copied from European examples and newly landscaped parks provided green retreats in the middle of increasingly crowded cities. Copying the practice of French Impressionists, American painters such as Maurice Prendergast, Childe Hassam, and William Merritt Chase recorded people enjoying themselves in these refuges, pushing baby carriages, riding on horses or in carriages, cooling next to fountains, or promenading in the open air.

MAURICE BRAZIL PRENDERGAST
Mothers and Children
in the Park

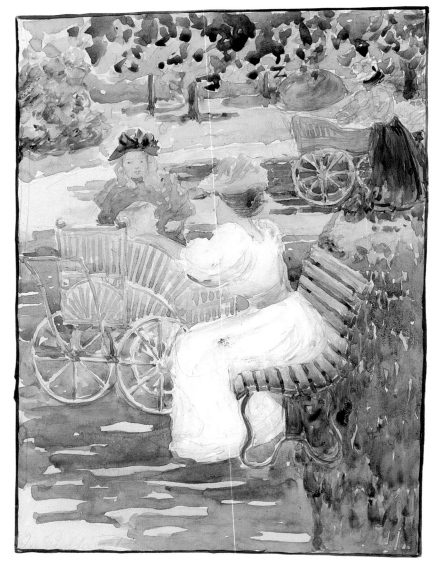

In the late 1850s Frederick Law Olmsted and Calvert Vaux, inspired by English romantic landscapes, designed Central Park to provide New Yorkers with a refuge. The eight hundred forty acres of forest, fields, and walks provided a taste of the country in the middle of the city and was one of the first of many such retreats that were built in America by the end of the nineteenth century. Later buildings were created copying European models, and city landscaping became more formal, symmetrical, and axial. In 1912 the will of Joseph Pulitzer, publisher of the *St. Louis Post Dispatch* and the *New York World,* stipulated that $50,000 be used for a fountain near the Plaza Hotel, at the 58th Street and Fifth Avenue entrance to Central Park, to be "like those in the Place de la Concorde, Paris, France."

At the turn of the century Congress organized a commission led by Senator James McMillan, to improve Washington, D.C., by expanding on L'Enfant's plan for the layout of the Capitol. The McMillan Commission traveled through Europe seeking inspiration. In France they visited the Bois de Boulogne, the Tuileries Gardens, the Luxembourg Gardens in Paris, and the grounds of Versailles, Fountainbleau, and Vaux le Vicomte; in Italy magnificent villas, the Piazza di San Pietro in Rome, and the Piazza San Marco in Venice; in England Hatfield House and Hampton Court. Senator McMillan then stated their conclusion: "It is the general opinion that for monumental work, Greece and Rome furnish the style of architecture best adapted to serve the manifold wants of today, not only as to beauty and dignity, but as to utility." McKim, Mead and White, the foremost architectural firm for the Classical style, was hired to carry forward this concept.

In the last decades of the century, well-situated towns were attracting the new rich and exploding into fashionable resorts. There the well-off could escape the heat of summer and partake in a round

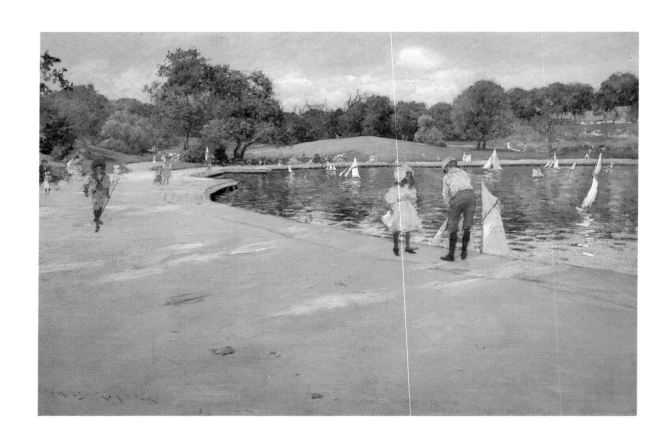

WILLIAM MERRITT CHASE
Lilliputian Boat Lake, Central Park

of social events—teas, picnics, dinners, and dances as well as sports like yachting, tennis, golf, and polo. In the 1870s, Bar Harbor, Maine, was becoming a popular resort with comfortable summer houses in the new shingle style.

Newland Archer in *The Age of Innocence* tries to persuade his bride May

> to spend the summer on a remote island off the coast of Maine (called appropriately enough, Mount Desert), where a few hardy Bostonians and Philadelphians were camping in "native" cottages, and whence came reports of enchanting scenery and a wild, almost trapper-like existence amid woods and waters.

And at Lenox and Lake Forest, and around Philadelphia, New York, and Detroit, country places, substantial houses with large formal gardens, began to decorate the landscape.

In Newport, by the 1890s huge marble "cottages" sprouted along the cliffs. Henry James felt that Newport "now bristles with the villas and palaces into which the cottages have all turned." These large "white elephants" lining the shore had distorted this formerly simple seaside town:

> The white elephants . . . make now for three or four miles, a barely interrupted chain. . . . What an idea, originally, to have seen this miniature spot of earth, where the sea-nymphs on the curved sands, at the worst, might have chanted back to the shepherds, as a mere breeding-ground for white elephants! They look queer and conscious and lumpish—some of them, as with an air of the brandished proboscis, really grotesque—while their averted owners, roused from a witless dream, wonder what in the world is to be done with them.

Shadow Brook, the house of Anson Phelps Stokes in Lenox, boasted one hundred rooms. The son of the owner, Anson Phelps Stokes, Jr., a member of the class of '96 at Yale, is supposed to have wired his mother from Yale, "Arriving this evening with a crowd of '96 men." She replied: "Many guests already here. Have only room for fifty."

Lila Vanderbilt and her husband, Seward Webb, chose the shore of Lake Champlain near Shelburne, Vermont, for the site of their red shingle and gray stone house, which adjoined thousands of acres of working farmland. And in Asheville, North Carolina, Lila's brother, George Vanderbilt, conceived and constructed Biltmore, the largest house in the country, boasting more than two hundred rooms and built to the scale of the mountains behind it. As a young man George Vanderbilt had inspected châteaux in France with the architect Richard Morris Hunt, to get ideas for his enormous house.

Edith Wharton went several times to stay at Biltmore, where she enjoyed the vast gardens and greenhouses. In 1905 she wrote to her friend Sally Norton:

In this matchless weather the walks thro' the park are a joy I should like to share with you—great sheets of fruited ivy pouring over terrace walls, yellow stars still shining on the bare branches of the nudiflora, jasmine, and masses of juniper, heath, honeysuckle, rhododendron and laurel making an evergreen covert so different from our denuded New England lanes.

Henry James liked it less:

the strange, colossal heart-breaking house. . . . It's, in effect, like a gorgeous practical joke but at one's own expense, after all, if one has to live in solitude in these league-long marble halls, and sit in alternate Gothic and Palladian cathedrals, as it were, where now only the temperature stalks about with the "regrets," sighing along the wind, of those who have declined.

One might wonder about their different reactions. James, returning to America after his long absence abroad, was shocked by the way the new prosperity and materialism were transforming the country. He visited Biltmore in February and, suffering from gout, he found the long halls and the stony atmosphere of this "glacial phantasy" most unwelcoming. Wharton, who always delighted in a gathering of genial and interesting friends, had pleasant house party times there.

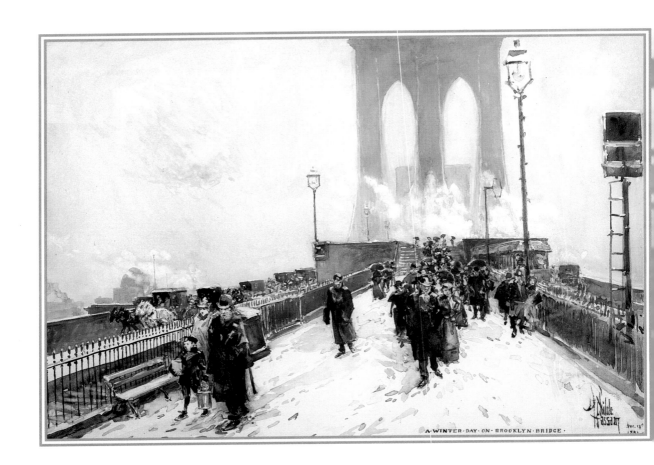

A · WINTER · DAY · ON · BROOKLYN · BRIDGE ·

FREDERICK CHILDE HASSAM
A Winter Day on Brooklyn Bridge

◆ ◆ ◆

While Paul Bourget found the luxurious mansions very
European, when he saw the Brooklyn Bridge, which
had been completed in 1883, he knew that he was
beholding an American phenomenon of both beauty
and terror:

> *Seen even from afar, this bridge astounds you like one*
> *of those architectural nightmares given by Piranesi in*
> *his weird etchings. You see great ships passing*
> *beneath it, and this indisputable evidence of its height*
> *confuses the mind. But walk over it, feel the quivering*
> *of the monstrous trellis of iron and steel interwoven for*
> *a length of sixteen hundred feet at a height of one*
> *hundred and thirty-five feet above the water; see the*
> *trains that pass over it in both directions, and the*
> *steamboats passing beneath your very body, while car-*
> *riages come and go, and foot passengers hasten*
> *along, an eager crowd, and you will feel the engineer*
> *is the great artist of our epoch.*

MAURICE BRAZIL PRENDERGAST
Central Park

❖ ❖ ❖

The extent of the Park is enormous, and you stand amazed when, having followed paths embowered in verdure, others winding around a lake, still others bordering immense fields where sheep are feeding, you perceived above the thick green of the clumps of trees a train flying over a track of red metal, thirty feet up in the air, and the city beginning all over again.

A whole people throng its paths this Sunday afternoon, a veritable nation of working folk at rest. I have not met two private victorias on these roads, swarming as they are with vehicles. They are all pleasure carriages, packed full with women and children. . . . The people who pass you by in these vehicles and on the sidewalks are substantially dressed and without elegance. . . . It is like an immense walking emporium of ready-made clothes. Nevertheless, an air of social health and good humor breathes from this crowd.

—Paul Bourget, *Outre-Mer*

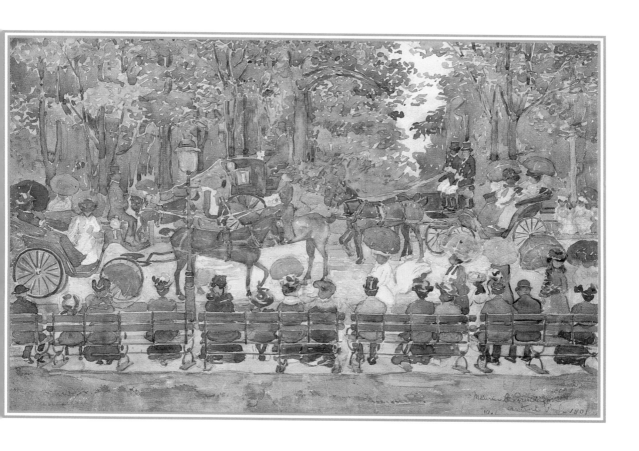

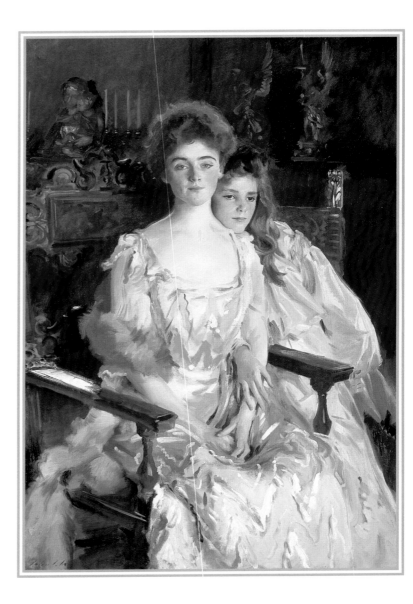

III
The Arts

♦ ♦ ♦

Whatever their occupation, [the sitters for the fashionable portrait painter, Mungold] looked straight out of the canvas, giving the impression that their eyes were fixed on an invisible camera. This gave rise to the rumor that Mungold "did" his portraits from photographs; it was even said that he had invented a way of transferring an enlarged photograph to the canvas, so that all that remained was to fill in the colors. If he heard of this charge he took it calmly, but probably it had not reached the high spheres in which he moved, and in which he was esteemed for painting pearls better and making unsuggestive children look lovelier, than any of his fellow craftsmen.

—Edith Wharton, *"The Potboiler"*

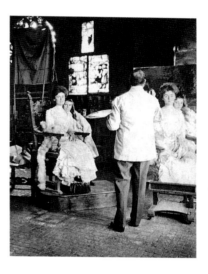

John Singer Sargent painting at Fenway Court

One sign of the new prosperity was an increased interest in the arts—in collecting, in beautifying one's house, and in having one's portrait painted. A fine collection of paintings and sculptures was proof of power and social status. As Paul Bourget noted: "One must hear the Americans utter the word *art,* all by itself, without the article, to understand the intense ardor of their desire for refinement; and this word *refined* also recurs continually in the conversation of the members with whom I visited the [Players' Club]." By the end of the century, academies such as the National Academy of Design (the first of its kind) in New York

◆ ◆ ◆

Edith Wharton noted that at the
end of the century:

The Metropolitan Museum was
waking up from its long lethargy,
and the leading picture dealers from
London and Paris were seizing the
opportunity of educating a new
clientèle, opening branch houses in
New York and getting up loan
exhibitions.

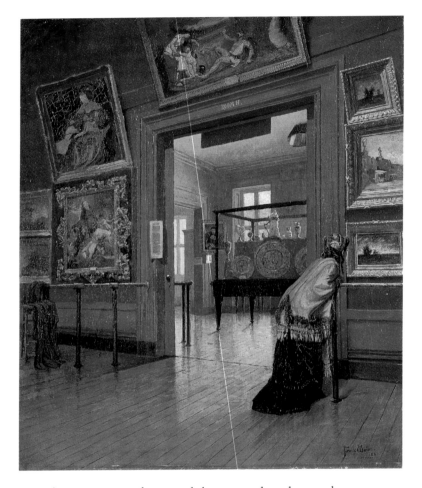

were thriving centers for art exhibitions and studies, and art muse-
ums were being built in the big cities. Schooling in Paris, Rome, or
Munich became necessary for the Yankee painter or sculptor's edu-
cation. These artists would then return, cosmopolitan and trained,

to work in their own country. In the Gilded Age, portrait painters depicted the well-off, and the temper of life was reflected in the shimmering, light-saturated canvases of the American Impressionists.

The Gilded Age would produce collectors in profusion. Two of the most interesting were Isabella Stewart Gardner and J. Pierpont Morgan. Isabella Stewart, a New Yorker, married the Boston patrician John Lowell Gardner and brought her lively personality and aesthetic taste to the more conservative society of that city. She assembled a collection and displayed it in a replica of a Venetian palace, whose beauty and evocative quality represents the best in Gilded Age collecting. When you enter her house today (it is now a museum), you see a Spanish cloister, medieval ironwork, Mexican tiles, and *El Jaléo,* Sargent's magnificent painting of a flamenco dancer. A flower-filled courtyard with classical sculpture beckons beyond.

One can read Mrs. Gardner's personality in this house and its collection. Her story is also told by the many portraits of her—by Anders Zorn, by James Abbott McNeill Whistler, and several by Sargent, who was a close friend. They show not a classic beauty, but a spirited woman with great style. Trying to emerge from the depression that followed the death of her infant son, Isabella Gardner went to Europe and became fascinated by art. Eventually the gifted connoisseur Bernard Berenson became her mentor. She had helped him by financing his early travels and studies in Italy. Berenson purchased a magnificent collection of paintings for her. Today the museum includes, among its almost three hundred paintings, works by Rembrandt, Rubens, Van Dyck, Botticelli, Giotto, Piero della Francesca, and Titian. When Henry James saw Mrs. Gardner's creation in 1904, he was pleased that "so undaunted a devotion to a

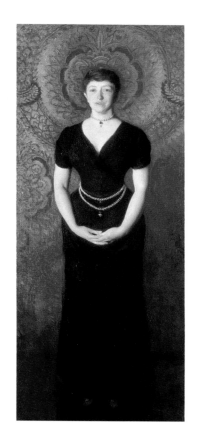

JOHN SINGER SARGENT
Isabella Stewart Gardner

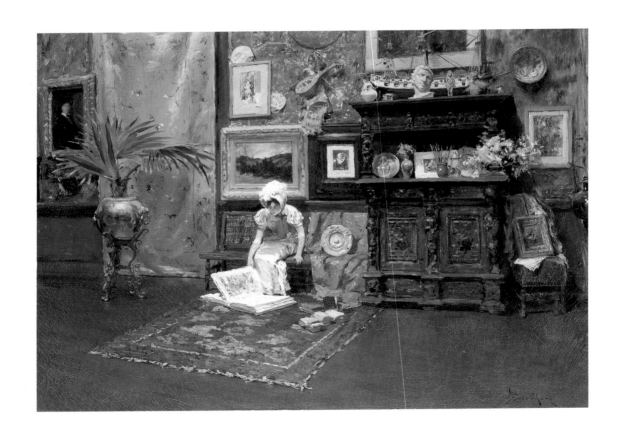

WILLIAM MERRITT CHASE
In the Studio

great idea . . . has been able consummately to flower. It is in presence of the results magnificently attained, the energy triumphant over everything, that one feels the fine old disinterested tradition of Boston least broken."

J. Pierpont Morgan was said to be so rich that he could buy anything from a pyramid to the tooth of Mary Magdalen. He felt that by acquiring beautiful works of art he could help America possess the moral, intellectual, and aesthetic qualities of European culture. During the Gilded Age, Morgan was a paramount influence over the nation's financial operations, far more influential than even the Secretary of the Treasury. European investors came to trust his character and rely on his advice, as they poured millions into American railroads and industries. He led the rescue of the United States government from collapse in 1895 and the national banking system, not to mention the city of New York, in 1907. In 1895 the gold reserve for the dollar was draining fast and, until Morgan stepped in, no one in Europe was willing to buy United States bonds. His wealth was inherited, but he made no effort to show it off and scorned those who did. He lived comfortably, went to church every Sunday, contributed generously of his time and money to charitable and civic causes, and, starting in middle age, collected books, manuscripts, and works of art on a vast scale. He approached art, wrote Frederick Lewis Allen, "as a venerator of old and choice and lovely things. What turned him to collecting was a romantic reverence for the archaic, the traditional, the remote, for things whose beauty took him far away from prosaic, industrial America—the same feeling, in essence, which made him delight in the ceremonies of the Church."

Morgan's love for Italian art was most apparent in the west room of his library, where he often held intimate business meetings.

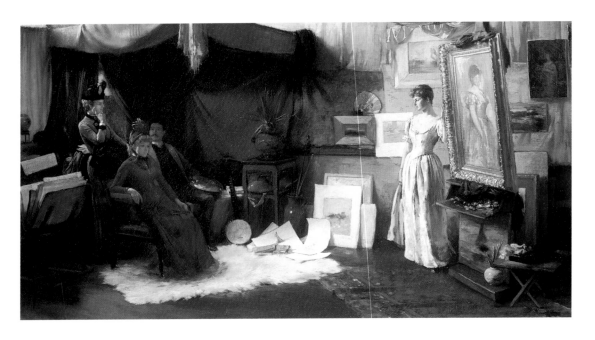

CHARLES COURTNEY CURRAN
Fair Critics

The walls were hung with red silk patterned with the coat of arms of the Chigi family of Rome. There were splendid Florentine masterpieces from the fifteenth and sixteenth centuries. As Allen describes it, "Morgan sat in a red plush armchair by the fire in this great room, with a *Madonna and Child* by Pinturicchio looking down over his shoulder, and Fra Filippo Lippi's altarpiece of *St. Lawrence and Saints Cosmo and Damian* facing him from the opposite wall."

According to Edith Wharton, old New York society held itself aloof from creative people, and only fraternized with artists and writers at the Century Club, the gathering place for artists, writers, and some socialites. In dinner party conversation, "art and music and literature were rather timorously avoided (unless Trollope's last

novel were touched upon, or a discreet allusion made to Mr. William Astor's audacious acquisition of a Bouguereau Venus), and the topics chiefly dwelt on were personal: the thoughtful discussion of food, wine, horses . . . the laying out and planting of country seats," and plans for European travel. Society did seek out portrait painters, however. To be painted was an important event and Wharton wrote often of artists and portrait painting in her fiction, touching on the issues of vanity, flattery, and narcissism. Being painted was also a proof of beauty. In *The Age of Innocence,* it was said of the young Ellen that she was so pretty she "ought to be painted." When she married Count Olenski and went to live in Europe, artists vied to have her sit for them. Her portrait was done nine times. Wharton was critical, however, of society's tendency to make a woman into an art object, another prize for the connoisseur's collection.

FERNAND PAILLET
Edith Wharton

Among the favorite society painters of the time were John Singer Sargent, Giovanni Boldini, William Merritt Chase, and Paul Helleu. Edith Wharton's friends were painted by them: Sargent painted Elizabeth Winthrop Chanler, Margaret Rutherfurd White, Egerton Winthrop; Boldini painted Consuelo Vanderbilt. Wharton and her friends also sat for miniature painters, such as Katherine Arthur Behenna and Fernand Paillet. The small "intimate keep-sakes," which friends and lovers carried with them before the advent of the photograph, had flourished in America from the mid-eighteenth century through the mid-nineteenth century, when they were superseded by the daguerreotype. Miniatures made a comeback, however, at the turn of the century.

William Merritt Chase, one of the most successful painters in America, was born in Indiana in 1846. His father, realizing his son had artistic talent that would be wasted in the family business,

encouraged his art studies. After study in the Midwest, and for several years at the Royal Academy in Munich, he came to New York in 1878 to teach at the Art Students League. There he soon found his place at the center of an exciting art world. Gregarious and dynamic, his enthusiasm drew people around him. William Merritt Chase was a dashing figure usually turned out in a cutaway, spats, top hat, and scarf with a flower in his lapel. His legendary studio on 10th Street attracted the rich and fashionable. The two vast rooms were crowded with *objets d'art*—paintings, sculptures, hangings. As a student described it, when you pushed the door "an ingenious mechanism sets a musical instrument in motion and [the] next moment you will find yourself face to face with the artist, in a dark, but sumptuous room, filled with treasures gathered together from half the curiosity shops in the old world," including purchases made in Europe, bronzes, and wonderful flowers. Another larger, less cluttered room contained his paintings and all was tended by a black servant dressed as a Nubian prince. It was in Chase's studio that the lovely Spanish dancer Carmencita performed. Both Chase and Sargent painted her. In addition to his portraits, Chase painted scenes that provide us with a dazzling record of everyday life at the time: the Shinnecock Hills on Long Island, Central Park, Prospect Park in Brooklyn, and the interior of his own studios in New York and on Long Island.

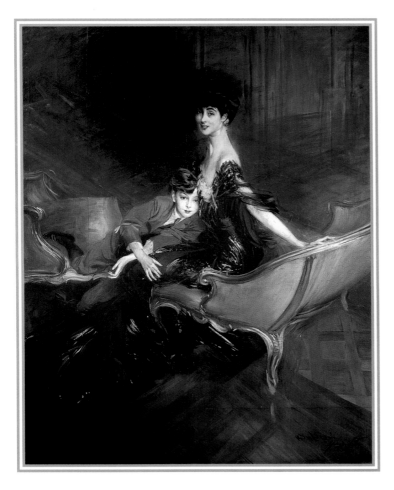

Consuelo, daughter of William K. Vanderbilt, was a long-time friend of Edith Wharton's. Consuelo's 1895 wedding in New York City to the ninth Duke of Marlborough was a ceremony of superlatives. In Wharton's last novel, *The Buccaneers*, Consuelo's unhappy marriage is mirrored in Nan St. George's marriage to the Duke of Tintagel. As Wharton noted, for the impoverished English nobleman, the negotiated settlement with his wife's family was critical.

GIOVANNI BOLDINI

Consuelo Vanderbilt, Duchess of Marlborough, and Her Son,
Lord Ivor Spencer-Churchill

Egerton Winthrop was a descendant of
Peter Stuyvesant of New York and
John Winthrop, governor of
Massachusetts. He had a taste for
French interiors and French writers.
He encouraged his good friend Edith
Wharton to read the works of Thomas
Henry Huxley and Charles Darwin
and was one of the few of her
Knickerbocker set who could discuss
ideas. He collected *objets d'art* and cre-
ated tasteful rooms in his New York
townhouse, designed in the late 1870s
by Richard Morris Hunt. Wharton
remembered him as "a lover of books
and pictures, an accomplished linguist
and eager reader, whose ever-youthful
curiosities first taught my mind to
analyse and my eyes to see."

Elizabeth Winthrop Chanler was
one of the "Astor orphans" who was
brought up at the family house,
Rokeby, on the Hudson River, with
her sisters and brothers. After
Sargent painted her portrait in
1893, he told a friend she had "the
face of the Madonna and the eyes
of the Child."

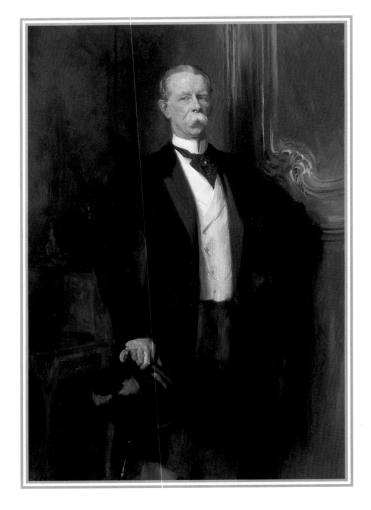

JOHN SINGER SARGENT
Egerton Leigh Winthrop

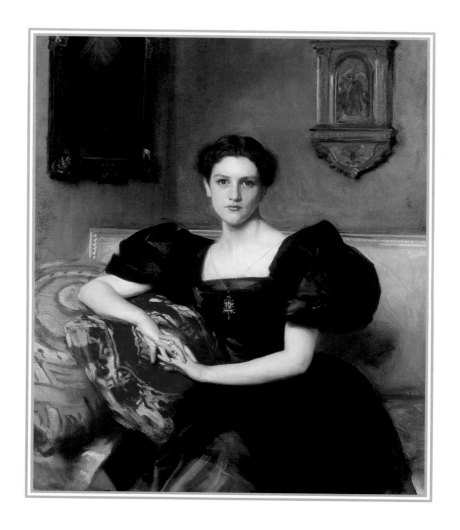

JOHN SINGER SARGENT
Elizabeth Winthrop Chanler (Mrs. John Jay Chapman)

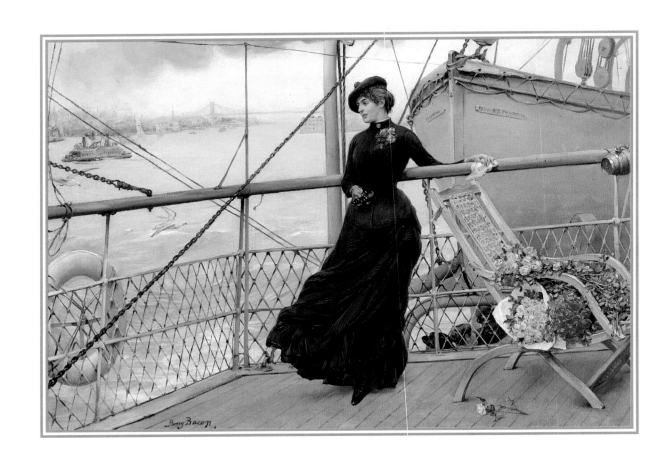

HENRY BACON

The Departure from New York Harbor

IV

European Travel
The American Abroad

◆ ◆ ◆

During that memorable month I basked in the happiness of being
for once in my life drifting with the tide of a great popular move-
ment. Everybody was going to Europe—I, too was going to Europe.
Everybody was going to the famous Paris Exposition—I too, was
going to the famous Paris Exposition. The steamship lines were car-
rying Americans out of the various ports of the country at the rate
of four or five thousand a week in the aggregate. If I met a dozen
individuals during that month who were not going to Europe shortly,
I have no distinct remembrance of it now.

—Mark Twain, *The Innocents Abroad*

Beginning early in the nineteenth
century, it became a must for cultured Americans to cross the ocean
to spend time in the Old World. Intellectuals felt that their under-
standing of life was not complete without intimate contact with the
culture of Europe. Many writers went abroad and were inspired to
describe the history, the landscape, and the art, as well as their own
profound reactions and the experiences of their countrymen there.
Washington Irving was one of the first to go abroad in 1804; after

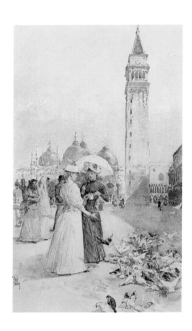

FREDERICK CHILDE HASSAM
Feeding the Pigeons in the Piazza

being a consul at Liverpool, Nathaniel Hawthorne lived in Italy in 1858 and 1859 and set *The Marble Faun* there; Mark Twain recorded American tourists' reactions to the Old World in *The Innocents Abroad;* Henry James became fascinated by "the international theme" and told many tales of Americans confronting different sets of manners; and toward the end of his life Henry Adams, grandson and great-grandson of presidents, went every year to Paris and toured medieval cathedrals. He found the "multiplicity" of modern times bewildering and saw the civilization of the Middle Ages as having a "unity," symbolized for him by the Virgin, which modern times lacked.

Artists and architects went to study at ateliers and at the Ecole des Beaux Arts in Paris, as well as to Rome and Florence. The well-off went to improve themselves, the ill went to benefit from the climate, and some went and settled there because it was simply less expensive and more interesting than staying at home. William Merritt Chase, on hearing that two wealthy St. Louis art patrons had raised $2,100 for his studies abroad, declared, "My God, I'd rather go to Europe than to Heaven."

Certain stops were *de rigueur.* English cathedrals were popular. Visits to France and Italy included a passage through the Alps and a stop on the Riviera. In Paris, American women frequented the fashionable couturiers. Big tourist hotels flourished at Vevey and other sites on Lake Geneva, as did spas such as Baden Baden in Germany, where one went to "take the waters." Some of the more adventurous struck out for mainland Greece and the Aegean. In Rome everyone tried to visit the Forum and the Colosseum by moonlight.

A product of this cosmopolitan existence was John Singer Sargent. He was born in Florence where his parents were living in 1856. Growing up abroad, Sargent became fluent in French,

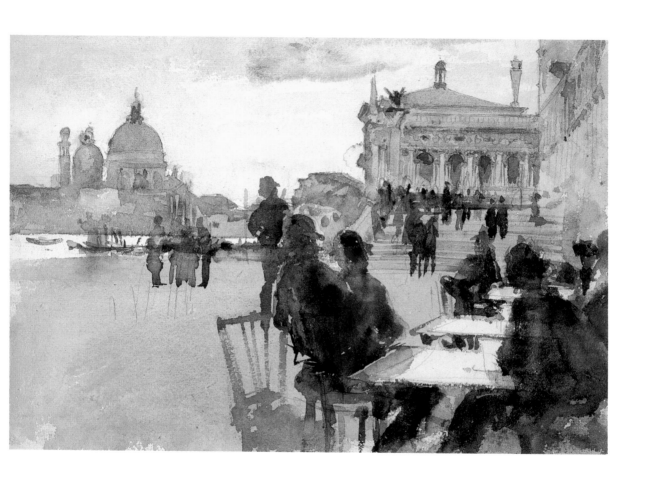

JOHN SINGER SARGENT
Cafe on the Riva degli Schiavoni, Venice

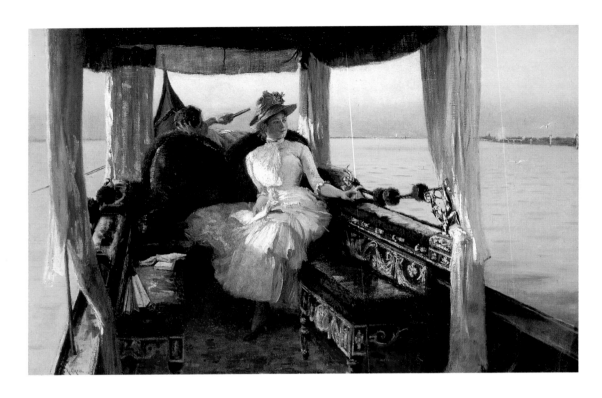

RALPH CURTIS
Drifting on the Lagoon, Venice

German, and Italian. Personable and talented he learned drawing as a youth and after studying in Paris with Emile Carolus-Duran, he won prizes at the Salon for his early paintings. After the scandal which followed the exhibition of *Madame X*—his glorious but shocking portrait of the pale skinned but alluring Madame Gautreau—he moved to England. Sargent's return to America in 1887 to paint the portrait of Mrs. Henry Marquand in Newport marked the beginning of his success there, and soon it became a sign of status to be painted by him. He was often in Venice where he painted interior

scenes of everyday life and watercolors of gondolas, palaces, and the Grand Canal. Like Whistler, Sargent recorded local color in the back alleys of a Venice whose days as a glorious sea power were long past.

Henry James also had an expatriate childhood, as his family spent long periods of time overseas. He was taken to Paris as an infant, lived in Geneva as a boy, studied in France, England, and Germany, and toured Italy as a young man in the 1860s. He lived for a while in Paris and finally, after 1876, made England his home. In his writing he placed his characters in similar situations, sending them across the Atlantic to confront the older societies. As Rebecca West wrote of James: "He was an American; and that meant, for his type and generation, that he could never feel at home until he was in exile."

In James's fiction we find a variety of experiences that show the impact Europe had on American visitors during the Gilded Age. In *Daisy Miller,* a pretty American girl travels to Europe with her family, spends time at a big tourist hotel at Vevey, and then with the American colony in Rome. Unaware of the proper response to art and culture, and oblivious to the social rules, Daisy meets disapproval and then disaster. But she was neither tacky nor vulgar, and she captured the hearts of readers. She was extremely well-dressed and represented American prosperity, freshness, energy, and naïveté. As James described her: "My supposedly typical little figure was of course pure poetry, and had never been anything else; since this is what helpful imagination, in however slight a dose, ever directly makes for."

In *The Portrait of a Lady* James created Isabel Archer, his most compelling heroine. Wishing to find out about life, she leaves Albany and goes abroad. Loved by three men—a masculine American, a liberal English nobleman, and an effete expatriate living in Florence— Isabel thinks she is choosing freedom and a great destiny when she

Ralph Curtis and his mother, Ariana, in the Palazzo Barbaro, Venice

marries the expatriate, Gilbert Osmond, but instead she is diminished by his narrow-minded personality. In this masterpiece James shows the English country house life, the expatriate Parisian existence, and the atmosphere of the American colonies in Florence and Rome.

Venice, with its evocative architecture and wonderful light, drew many Americans. The Palazzo Barbaro, a magnificent palace with stucco and gilded rooms on the Grand Canal, was bought in 1885 by Daniel Curtis, a Bostonian who had given up America after an incident on a train in which he had struck a judge who had taken his seat. Curtis was briefly imprisoned for this act, leading to his rejection of his country and his expatriate life. The Curtis's rooms on the Grand Canal became a meeting place for American and English society. Robert Browning read his poems there; Vernon Lee visited and she described the rooms as "full of beautiful furniture and pictures and at the same time absolutely unpretentious." Isabella Stewart Gardner rented the palazzo one summer, and James went to visit again and slept in the old library. As he described it:

> If you haven't gazed upward from your couch, in the rosy dawn, or during the postprandial (that is after luncheon) siesta, at the medallions and arabesques of the ceiling, permit me to tell you that you don't know the Barbaro.

He immortalized this magnificence in the Palazzo Leporelli in *The Wings of the Dove.*

Another American inspired by Venetian beauty was James A. M. Whistler who, in September 1879, left London and went to Venice to execute twelve commissioned etchings. He described being in the sea city at Christmas time as "struggling on in a sort of opera

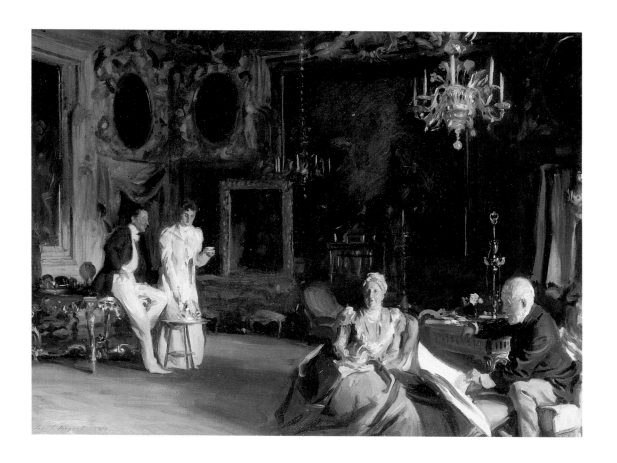

JOHN SINGER SARGENT
An Interior in Venice

In 1899 Sargent painted the Daniel Curtis family in the great rococo room of the Venetian palace, the Palazzo Barbaro, showing the details of chandeliers and lamps, paintings and mirrors in elaborately carved and gilded frames, and the handsome antique furniture.

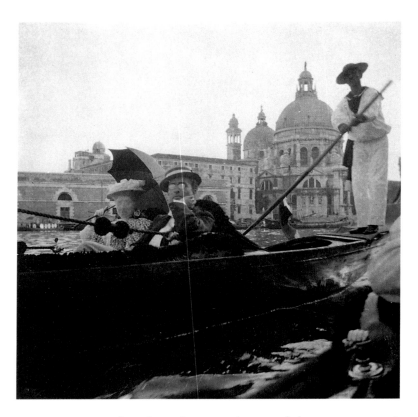

Isabella Stewart Gardner and
Gaillard Lapsley in a gondola
in Venice

comique country when the audience is absent and the season is over."
But he came to love it and stayed until the following November,
completing about fifty etchings, seven or eight oils, and many pastels
that captured the city's spell.

Travel writing was a popular genre for armchair travelers and
roaming tourists alike. In 1867, Mark Twain was hired by a
California newspaper to join what he called "the first organized plea-
sure party ever assembled for a trans-Atlantic voyage" and to report

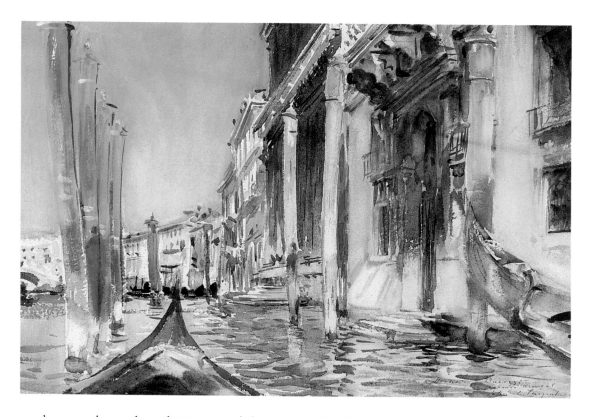

on their grand tour through Europe and the Holy Land. The result was *The Innocents Abroad, or the New Pilgrims' Progress*, the most entertaining travelogue written during the Gilded Age. He was out to expose, to tell his readers straight out, without romance or sentimentality, what the Old World was all about.

Mark Twain could find no fault with the French countryside that unfolded on the five-hundred-mile railroad trip from Marseilles to Paris: "What a bewitching land it is! What a garden!" Like all

American tourists, he was dazzled by the Rhone valley. Still, he needed to contrast it with an "infinitely more delightful" American journey, because for Mark Twain riding a stagecoach through the West—"scurrying through the great South Pass and the Wind River Mountains, among antelopes and buffaloes and painted Indians on the warpath"—was an even more exhilarating experience.

In the travel writing of Henry James we find the irresistible personalities of the French and Italian towns—the color, the mood, the spectacle of life in the present, the magic of the suggestions of the past. For James, places, like people, have personalities. "The smile of Rome . . . is ushered in with the first breath of spring. . . ." James's sketches give his impressions and reactions to such European towns and cities as Venice, Paris, and Rheims, and since boyhood he had learned on his travels to enjoy "wondering and dawdling and gaping."

Edith Wharton had a similar way of experiencing places, and what she saw—houses, landscapes, cathedrals, villas, gardens, and palaces—always sparked inward reactions and associations. At times her affinity for Europe alarmed her, as when she wrote a friend after returning from abroad:

> My first few weeks in America are always miserable, because the tastes I am cursed with are all of a kind that cannot be gratified here. . . . One's friends are delightful; but we are none of us Americans, we don't think or feel as the Americans do, we are the wretched exotics produced in a European glass-house, the most déplacé and useless class on earth! All of which outburst is due to my first sight of American streets, my first hearing of American voices, and the wild, disheveled backwoods look of everything when one first comes home!

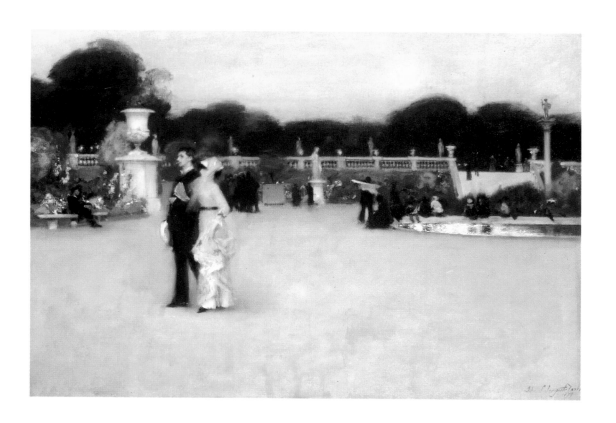

JOHN SINGER SARGENT
In the Luxembourg Gardens

Wharton's childhood memories of Europe inspired her to return again and again. She crossed the ocean between sixty and seventy times before she finally settled in France before World War I. She was continually nourished by the contrast between the American experience and the European experience. Her first novel *The Valley of Decision* was set in an eighteenth-century northern Italian duchy. Fascinated by the art and architecture of Italy, she then wrote *Italian Villas and Their Gardens* in 1903 and 1904 to explain the principles of Renaissance gardens to American readers. She understood that the beauty of this type of garden "lies in the grouping of its parts— in the converging lines of its long ilex-walks, the alternation of sunny open spaces with cool woodland shade, the proportion between terrace and bowling-green, or between the height of a wall and the width of a path." The Renaissance landscape architect had much to teach Americans for he "considered the distribution of shade and sunlight, of straight lines of masonry and rippled lines of foliage, as carefully as he weighed the relation of his whole composition to the scene about it."

Wharton's move to France made fantasy a reality, but also was logical, considering her love for the eighteenth century and for European history and ritual. She spent almost a decade living on the rue de Varenne in the aristocratic Faubourg Saint-Germain, savoring the atmosphere of this city of historic neighborhoods, lovely public gardens, and interesting intellectual and social life. After the war, she gave up the French capital. In postwar Paris all seemed changed—rushed, noisy, expensive, and lacking in charm. She retreated to two beautiful old houses in the French countryside where she could escape the confusing present and live with the ambience of the past.

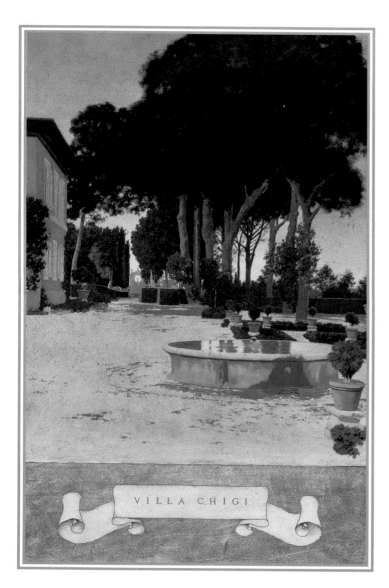

MAXFIELD PARRISH
Villa Chigi, Rome

◆ ◆ ◆

Edith Wharton hoped the reader would take her advice and, inspired by her aesthetic perceptions in *Italian Villas and Their Gardens*, build his own garden to bring "something of the old Italian garden-magic to his own patch of ground at home." Maxfield Parrish, the American illustrator, did beautiful paintings for the book, which she found too fanciful for the scholarly tone she was trying to establish.

FREDRICK CHILDE HASSAM
A Spring Morning

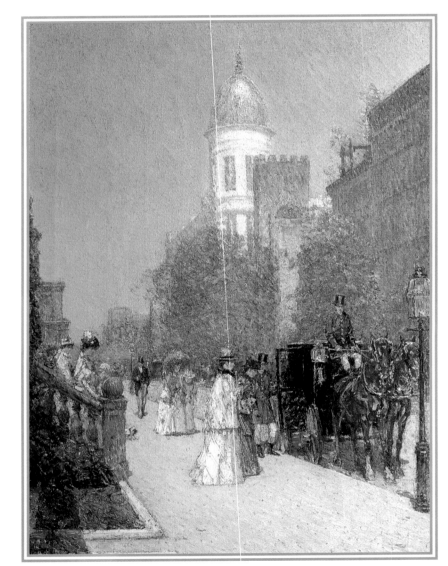

V

Society

♦ ♦ ♦

How many times in the course of this journey have people said to me:—"In Boston they ask you what you know; in New York, how much you are worth; in Philadelphia, who your parents were!"

—Paul Bourget's comments on American society, *Outre-Mer*

During the Gilded Age, Americans became concerned with social distinctions, and belonging to fashionable society was the goal of the ambitious. In Mark Twain's *The Gilded Age,* Laura discovers there were "three distinct aristocracies in Washington. One of these (nicknamed the Antiques) consisted of cultivated, high-bred old families. No. 2 was the aristocracy of the middle ground. . . . No. 3 lay beyond. . . . We will call it the Aristocracy of the Parvenus."

For the novelists James, Wharton, Mark Twain, and others, the social climbing and the rituals of the time—evening parties, balls, and the festivities surrounding weddings—provided wonderful material for studies of manners.

Edith Wharton explored the phenomenon of social climbing in several novels. In the beginning of *The House of Mirth* the social insider Lily Bart is a frequent guest at fashionable house parties and weddings. She enjoys the luxurious atmosphere of the well-off, knowing that "she was not made for mean and shabby surroundings, for the squalid compromises of poverty. Her whole being dilated in an atmosphere of luxury; it was the background she required, the only climate she could breathe in." But Lily doesn't want the luxury

of others and she cannot manage to produce her own. At the end of the novel, just before her death in a dingy boardinghouse room, from an overdose of chloral, Lily tells Lawrence Selden: "I have tried hard—but life is difficult, and I am a very useless person. I can hardly be said to have an independent existence. I was just a screw or a cog in the great machine I called life, and when I dropped out of it I found I was of no use anywhere else. What can one do when one finds that one only fits into one hole?"

On the other hand, Undine Spragg in *The Custom of the Country* is determined to improve her social position and successfully uses her beauty and energy in her swift ascent. She marries her way into New York society from Midwestern anonymity. It soon becomes clear, however, that Undine and her husband Ralph Marvell, a sensitive but passive man, are seriously mismatched. He learns that "an imagination like his, peopled with such varied images and associations, fed by so many currents from the long stream of human experience, could hardly picture the bareness of the small half-lit place in which his wife's spirit fluttered." Her narrow mind is fascinated only by money and position, and she soon tires of him and his conservative social world. "She had found out that she had given herself to the exclusive and the dowdy when the future belonged to the showy and the promiscuous; that she was in the case of those who have cast in their lot with a fallen cause, or—to use an analogy more within her range—who have hired an opera box for the wrong night." After a second mismatch, to a French aristocrat who also fails to give her the glamorous milieu she craves, she makes another try at matrimony in a second marriage to her first husband, a self-made businessman who hopefully will satisfy her consuming appetites. Neither Undine nor Lily can imagine herself making a life alone with her own talents.

In *The Buccaneers*, four American girls who are snubbed in New

York and Newport go to London for a season. The central character, Nan St. George, makes the most brilliant match, the young Duke of Tintagel, but like other Edith Wharton heroines she cannot be content with social position and prestige alone. As her creator describes Nan's situation: "though she is dazzled for the moment her heart is not satisfied. The Duke is kindly but dull and arrogant, and the man she really loves is young Guy Thwarte, a poor officer in the guards. . . ." Wharton's last novel was unfinished when she died but she had planned to end it by having Nan leave her husband and join her lover, putting personal fulfillment before society's demands.

Both William Dean Howells and Edith Wharton showed how a social ritual like the dinner party could take on profound importance. At the climactic dinner in *The Age of Innocence* the women of New York society close ranks to protect the marriage of Newland and

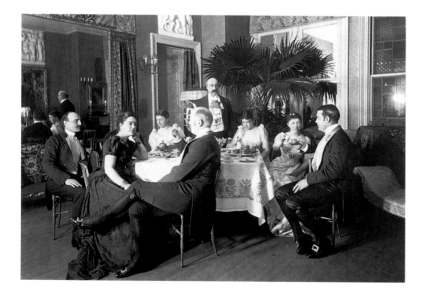

Isabella Stewart Gardner, John Lowell Gardner, and guests having dinner at Beacon Street

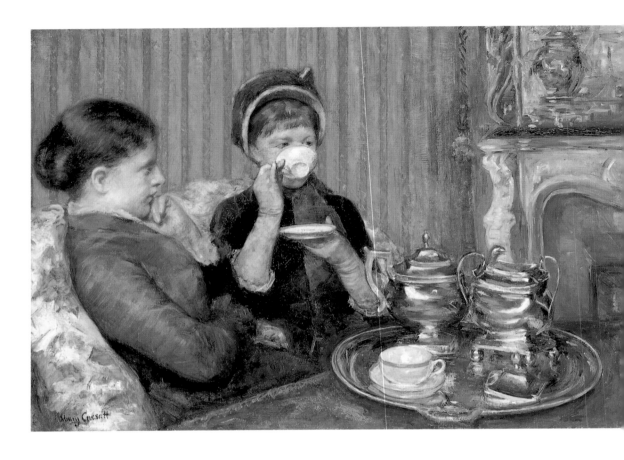

MARY STEVENSON CASSATT
Five O'Clock Tea

May, and banish the threatening Countess Olenska to exile in Paris. The scene is rich in details which evoke the social customs of the time. The mothers of Newland and May agree that it was "a great event for a young couple to give their first big dinner." On this important occasion, there would be a

hired chef and two borrowed footmen, with Roman punches, roses from Henderson's and menus on gilt-edged cards. . . . *As Mrs.*

*Archer remarked, the Roman punch made all the difference; not in
itself but by its manifold implications—since it signified either can-
vasbacks or terrapin, two soups, a hot and a cold sweet, full décol-
letage with short sleeves, and guests of a proportionate importance.*

The dinner party in *The Rise of Silas Lapham* becomes the
meeting place for the two families whose manners and fortunes the
reader has been comparing and contrasting. The Laphams, who have
recently become wealthy in the paint business, and the more cultivat-
ed and patrician Corey family represent the new and old money of
Boston. The anxiety of the Laphams is expressed in their choosing
what to wear. Silas agonizes over whether or not gloves are suitable
with his evening clothes, and he even consults an etiquette book.
The women are more sure of themselves: "Mrs. Lapham had decided
against low-necks on her own responsibility, and had entrenched her-
self in the safety of a black silk, in which she looked very handsome."
Her daughter Irene wore a dress in a shade of green or blue, and "if
it was more like a balldress than a dinner dress, that might be
excused to the exquisite effect." She is lovely, and "the consciousness
of her success brought a smile to her face. Lapham, pallid with anxi-
ety lest he should have been spared the shame of wearing gloves when
no one else did, but at the same time despairing that Corey should
have seen him in them, had an unwonted aspect of almost pathetic
refinement."

Edith Wharton often used the details of clothes to express the
rigidity of society's demands. At the end of *The Age of Innocence,* she
writes that May Archer's "life had been as closely girt as her figure."
And in *The House of Mirth,* Laurence Selden takes note of the strug-
gles of Lily Bart: "As he watched her hand, polished as a bit of old
ivory, with its slender pink nails, and the sapphire bracelet slipping

over her wrist," he realized that she was "so evidently the victim of the civilization which had produced her, that the links of her bracelet seemed like manacles chaining her to her fate."

The spectacle scenes in *The Age of Innocence* bring back the social events of Edith Wharton's youth and allow the novelist to use her great visualizing gift. The novel opens at the opera at the Academy of Music where "the world of fashion was still content to reassemble every winter." Turned out in evening clothes, all the important players in this drama are presented against an architectural background. They immediately spot Ellen Olenska as an outsider in her exotic and unusual evening dress. After the performance, Newland Archer repairs to the ball at ~~the~~ Julius Beaufort's:

> *Couples were already gliding over the floor beyond: the light of the wax candles fell on revolving tulle skirts, on girlish heads wreathed with modest blossoms, on the dashing aigrettes and ornaments of the young married women's coiffeurs, and on the glitter of highly glazed shirtfronts and fresh glacé gloves.*

A woman's life was marked by its social rituals. The debut introduced her into society, the wedding determined her life. At the time weddings of the rich were lavish, theatrical productions. Edith Wharton described how the guests were transported in special trains; crowds of uninvited onlookers had to be fended off by the police; members of the press barged into the church, which was packed with the fashionable and decorated with floral profusion. Newland Archer reflects at his own wedding that the social world that turned out to witness the exchange of vows was very like society habitually showing itself at the opera:

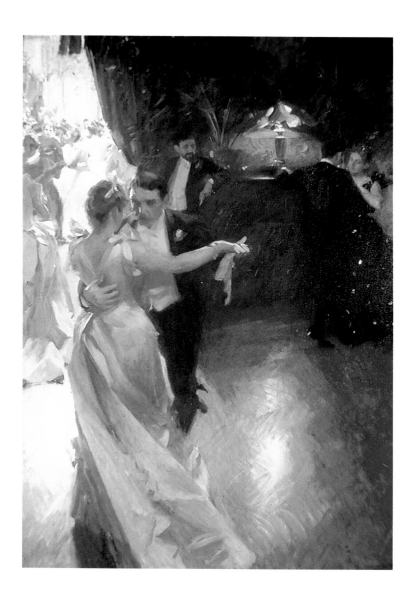

ANDERS ZORN
The Waltz

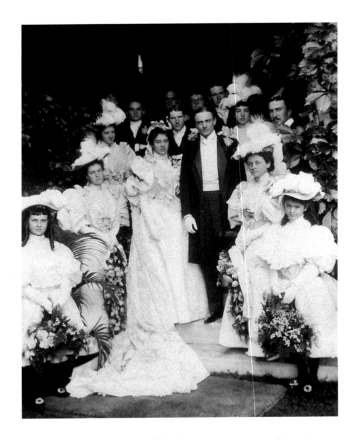

The wedding of Florence Adele Sloane to James Burden in June 1895, was, according to *The New York Times* "one of the most elaborate and costly affairs of this kind ever given in this country."

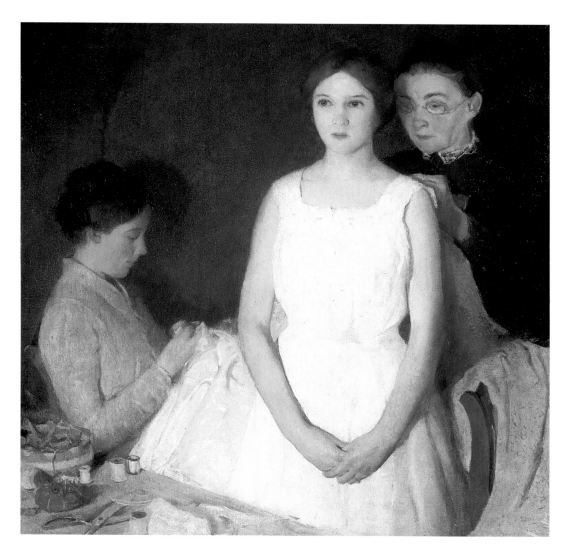

CHARLES WEBSTER HAWTHORNE
The Trousseau

"How like the first night at the opera!" he thought, recognizing all the same faces in the same boxes (no, pews), and wondering if, when the Last Trump sounded, Mrs. Selfridge Merry would be there with the same towering ostrich feathers in her bonnet, and Mrs. Beaufort with the same diamond earrings and the same smile—and whether suitable proscenium seats were already prepared for them in another world.

Once a woman was married, the duties of the society wife were numerous, and one of the most important was to run an efficient household. "Mrs. Julius Beaufort, on the night of her annual ball, never failed to appear at the Opera; indeed, she always gave her ball on an Opera night in order to emphasize her complete superiority to household cares, and her possession of a staff of servants competent to organize every detail of the entertainment in her absence."

Mark Twain found humor in the female custom of calling and leaving cards, commenting on how two women could maintain a satisfactory relationship without ever seeing one another or having a cup of tea. A society lady merely visits the other's home once a year and leaves her card, with the proper corner turned down:

If Mrs. B's husband falls down-stairs and breaks his neck, Mrs. A calls, leaves her card with the upper right-hand corner turned down, and then takes her departure; this corner means "Condolence." It is very necessary to get the corners right, else one may unintentionally condole with a friend on a wedding or congratulate her upon a funeral.

During the Gilded Age, both men and women enjoyed sporting events. Edith Wharton remembered that at Newport in the early 1880s the new game of lawn tennis was played by young ladies in tight whale-boned dresses and young gentlemen in long white

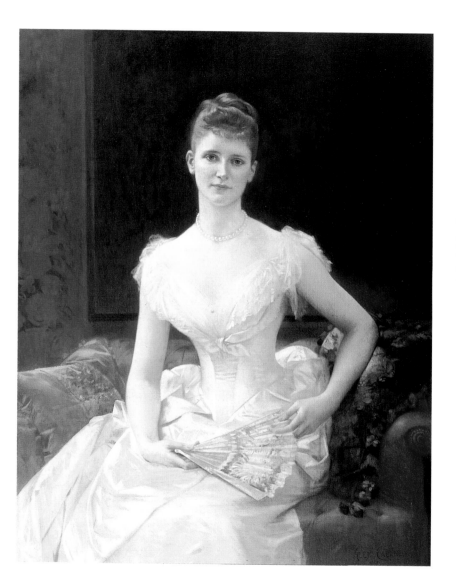

ALEXANDRE CABANAL
Mrs. William Bayard Cutting

❖ ❖ ❖

Edith Wharton's friend Olivia
Cutting typified the gracious
society woman of the time. As
her granddaughter Iris Origo
described her fifteen years after
Cabanal painted her, she was

*a skillful and experienced host-
ess, an elegant woman of fash-
ion. . . . I can see her sitting
very erect, as was required of a
well-bred woman, with her long-
gloved arm resting on the red
plush rim of her box at the
Metropolitan Opera House,
most elegantly gowned, gloved
and bejewelled, in the company
of friends of equally irreproach-
able character, breeding, and
appearance.*

trousers, and that steam yachts were just beginning to be the favorite toys of the rich. The Newport Casino, the large, shingled clubhouse where lawn tennis was played, designed by McKim, Mead and White, was built in the early 1880s on land owned by James Gordon Bennett, Jr., heir to the *New York Herald*. A friend of Bennett's had been ousted for outrageous behavior from the Newport Reading Room, and the Casino was built as an alternate gathering place. In addition to tennis courts, there was a theater, a restaurant, lovely piazzas for strolling, and stands for spectators to watch this beautiful sport in which athletes dressed in white played on green turf. The first national lawn tennis tournament was held there in 1881.

When Paul Bourget visited Newport in 1892 he witnessed the many sporting events—including yachting, tennis, and polo—which alternated with teas, concerts, dinners, and dances. At Newport and other resorts the rich indulged in what Wharton called "watering place mundanities."

The way of life we associate with the Gilded Age came to an end with the First World War. Mark Twain died in 1910, pessimistic and saddened by the death of his two daughters and wife before him and chastened by the loss of money in his many speculative schemes. Henry James died in 1916, greatly depressed by the War and having given up his American citizenship. Edith Wharton worked diligently throughout the war organizing charities and reporting on the fighting. Afterward she moved to the French countryside where she continued to write and cultivate beautiful gardens.

Just before her death in 1937, Wharton looked back once again to the years of her childhood: "When four years ago I wrote the closing lines of my reminiscences, *A Backward Glance,* I thought of myself as an old woman laying a handful of rue on the grave of an age which had finished in storm and destruction." Now, she felt that

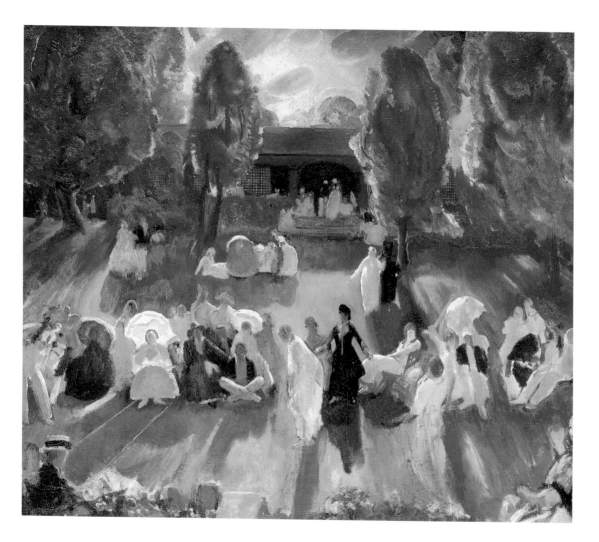

GEORGE WESLEY BELLOWS
Tennis at Newport

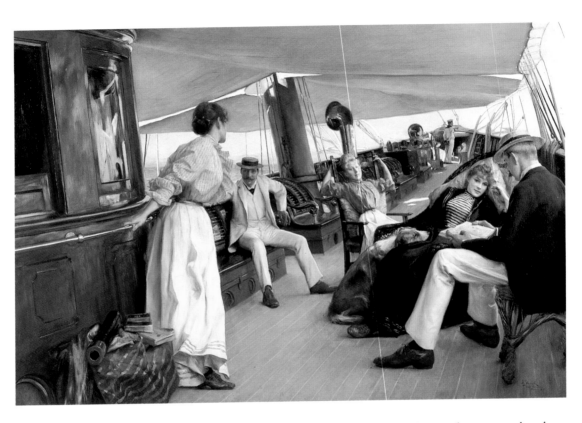

*the succeeding years have witnessed such convulsions, social and
political, that those earlier disturbances now seem no more than a pre-
monitory tremor; and the change between the customs of my youth
and the world even ten years ago a mere crack in the ground com-
pared with the chasm now dividing that world from the present one.*

An even greater chasm now divides the present from those past
years, but those years remain ever fascinating.

Notes

◆ ◆ ◆

Numbers preceding entries refer to page numbers.

8 The Henry James quotation is from Charles du Bos, unpublished memoir of Edith Wharton, Wharton Archives, Beinecke Library, Yale University, New Haven, Connecticut.

10 In "A Little Girl's New York," *Harper's Magazine,* March, 1938, p. 356, Edith Wharton lamented the changes in her world.

10 In *The Gilded Age,* written with Charles Dudley Warner, Mark Twain used his lively humor to satirize the current business and political scene. In tune with America's compulsion to get rich quick, Squire Hawkins and Colonel Sellers venture into hopelessly flawed business speculations in Tennessee and Missouri. In one of the many plots, Laura, Hawkins's beautiful, talented, and unscrupulous adopted daughter, conquers Washington, and the reader is introduced to Congressional corruption on a grand scale. When Laura shoots the man who has spurned her, the highest-paid criminal lawyer in New York persuades a jury of illiterate Irishmen to find her "not guilty."

12 See Justin Kaplan, *Mr. Clemens and Mark Twain,* New York: Simon & Schuster, 1966, p. 31, p. 77, for his interesting analysis of Mark Twain's two personalities. As he describes the writer: "He was, at the very least, already a double creature. He wanted to belong, but he also wanted to laugh from the outside." Kaplan p. 18.

14 Edith Wharton, *A Backward Glance,* New York: Scribner's, 1933, 1964, pp. 206–7.

14–15 The Beaux Arts architecture at the Chicago fair prompted different reactions. Richard Watson Gilder, editor of *Century Magazine,* was inspired to write poetry: "Ah! Happy West — / Greece flowers anew, and all her temples soar!" For Louis Sullivan, the country's most innovative architect, the wild enthusiasts for the classical style were "carriers of contagion, unaware that what they beheld and believed to be true was to prove, in historic fact, a calamity." The damage of thinking that ancient ideas were right for America's industrial and democratic society, Sullivan believed, would "last for half a century from its date, if not longer."

15 Pierre Du Pont would later be the chairman of the Du Pont Company and the General Motors Company.

17–18 Louis Auchincloss compares the two portraits of the Vanderbilt and Astor families in *The Vanderbilt Era,* New York: Macmillan, 1989.

21 Edith Wharton, *The Age of Innocence,* New York: Scribner's, 1968, pp. 21–22.

22 Paul Bourget, *Outre-Mer: Impressions of America,* New York: Scribner's, 1925, p. 25.

22 Henry James, *The American Scene,* Bloomington, Indiana: Indiana University Press, 1968, pp. 248–249.

23 Edith Wharton, *A Backward Glance,* p. 2.

25 Edith Wharton, *A Backward Glance,* pp. 54–55; 148.

27 Margot Gayle and Michele Cohen describe the building of the Pulitzer Fountain (1913–1916) in *Manhattan's Outdoor Sculpture,* New York: Prentice Hall, 1988.

27 The Recommendations of the McMillan Commission are quoted in *The American Renaissance: 1876–1917,* published by the Brooklyn Museum, New York: Pantheon, 1979, p.12.

29 The shingle style was the style of domestic architecture favored by cottage-builders at fashionable watering places throughout the eastern United States. The style was characterized by external wood shingling, assymetrical masses and open interior plans and was made popular by such notable architects as Henry Hobson Richardson, McKim, Mead and White, and William Ralph Emerson.

29 Edith Wharton, *The Age of Innocence,* p. 205.

29 Henry James, *The American Scene,* p. 224.

30 Shadow Brook. See Cleveland Amory, *The Last Resorts,* New York: Harper & Row, 1948, 1951, 1952, p. 16.

31 Edith Wharton, *The Letters of Edith Wharton,* R.W.B. Lewis and Nancy Lewis, eds., New York: Macmillan, 1988, p. 100.

31 Henry James, *Henry James Letters,* Vol. IV. Leon Edel, ed., Cambridge: Belknap Press, 1984, pp. 346–47.

33 Paul Bourget, *Outre-Mer,* pp. 25–26.

34 Paul Bourget, *Outre-Mer,* pp. 29–30.

37 Edith Wharton, "The Potboiler," *Collected Short Stories of Edith Wharton,* Vol. 1. R.W.B. Lewis, ed., New York: Scribner's, 1968, pp. 671–72.

37 Paul Bourget, *Outre-Mer,* p. 35.

38 Edith Wharton, *A Backward Glance,* p. 148.

39 Rollin Van N. Hadley, *Museums Discovered: Isabella Stewart Gardner Museum,* New York: Shorewood Fine Art Books, 1981.

39–40 Henry James commented on Mrs. Gardner's museum and collection in *The American Scene,* pp. 254–255.

41–42 Frederick Lewis Allen, *The Great Pierpont Morgan,* New York: Harper & Brothers, 1949, p. 147; 256.

42–43 Edith Wharton, *A Backward Glance,* p. 61.

44 Ronald G. Pisano, *William Merritt Chase: A Leading Spirit in American Art,* Seattle: University of Washington Press, 1983, pp. 24–48.

46 Edith Wharton, *A Backward Glance,* p. 94.

46 Lately Thomas, *A Pride of Lions: The Astor Orphans*, New York: Morrow, 1971, p. 181.

49 Mark Twain, *The Innocents Abroad, or the New Pilgrims' Progress*, New York: Signet, 1966, p. 24.

50 See Van Wyck Brooks, *Dream of Arcadia: American Writers and Artists in Italy 1760–1915*, New York: Dutton, 1958, for a discussion of Americans in Italy.

50 William Merritt Chase, quoted in Russell Lynes, *The Art-Makers: An Informal History of Painting, Sculpture and Architecture in Nineteenth-Century America*, New York: Dover, 1970, p. 425.

50 For a good discussion of the American abroad and a collection of impressions of Americans from the seventeenth century to the present, see Frank MacShane, *The American in Europe*, New York: Dutton, 1965.

50–53 For Sargent's experience see Stanley Olson, *John Singer Sargent: His Portrait*, London: Macmillan, 1986.

53 Rebecca West quoted by Zabel in Henry James, *The Portable Henry James*, Morton Dauwen Zabel, ed., New York: Viking, 1956, pp. 12–13.

53 Henry James is quoted in Leon Edel, *Henry James: A Life*, condensed version, New York: Harper & Row, 1985, p. 218.

53 In Henry James's *The American*, Christopher Newman, the enthusiastic, self-made businessman from California, tries to penetrate Faubourg society. The same theme—naïve American meets European sophisticated society—is reworked years later in *The Ambassadors*, in which Chad Newsome goes off to France and gives up his Massachusetts routine for a wonderful expatriate existence. When other "ambassadors" are sent to bring him home, one, the aging widower Lambert Strether, finds himself face to face with life for the first time.

54 Henry James quoted in Hugh Honour and John Fleming, *The Venetian Hours of Henry James, Whistler, and Sargent*, Boston: Little, Brown and Co., 1991, p. 83.

54–56 Vernon Lee and J.A.M. Whistler are quoted in Hugh Honour and John Fleming, *The Venetian Hours of Henry James, Whistler, and Sargent*, p. 75; 37.

57–58 Mark Twain, *Innocents Abroad*, pp. 78–79.

58 Henry James, *The Portable Henry James*, p. 495.

58 Edith Wharton's letter is in *The Letters of Edith Wharton*, p. 84.

60 Edith Wharton, *Italian Villas and Their Gardens*, New York: The Century Co., 1920, p. 8.

63 Paul Bourget, *Outre-Mer*, p. 72.

63 For a discussion of these novelists of manners see James Tuttleton, *The Novel of Manners in America*, New York: W.W. Norton, 1974.

63 Mark Twain and Charles Dudley Warner, *The Gilded Age: A Tale of To-Day*, New York: Harper & Brothers, 1915, Vol. 2, p. 9.

63–64 Edith Wharton, *The House of Mirth*, New York: Scribner's, 1905, pp. 25–26; 308.

64 Edith Wharton, *The Custom of the Country*, New York: Scribner's, 1913, p. 147; 193.

65 Edith Wharton, *Fast and Loose and The Buccaneers*, Viola Hopkins Winner, ed., Charlottesville: University Press of Virginia, 1993, p. 478.

66–67 Edith Wharton, *The Age of Innocence*, p. 327.

67 William Dean Howells, *The Rise of Silas Lapham*, Edwin H. Cody, ed., Boston: Houghton Mifflin, 1957, p. 154.

67 Edith Wharton, *The Age of Innocence*, p. 349.

67–68 Edith Wharton, *The House of Mirth*, p. 7.

68 Edith Wharton, *The Age of Innocence*, p. 23.

72 Edith Wharton, *The Age of Innocence*, pp. 180–181; 19.

72 Mark Twain, *The Gilded Age*, Vol. II, pp. 10–11.

73 Olivia Cutting: Iris Origo, *Images and Shadows: Part of a Life*, New York: Harcourt Brace Jovanovitch, 1970, pp. 26–27.

74 Wayne Andrews, *Architecture, Ambition and Americans*, New York: Macmillan Free Press, 1979, p. 166.

74–76 Edith Wharton, "A Little Girl's New York," *Harper's Magazine*, March, 1938.

Recommended Reading

❖ ❖ ❖

Auchincloss, Louis. *The Vanderbilt Era*, New York: Macmillan, 1989.

Dwight, Eleanor. *Edith Wharton: An Extraordinary Life*, New York: Harry N. Abrams, Inc., 1994.

Edel, Leon. *Henry James: A Life*, New York: Harper & Row, 1953, 1977.

Honour, Hugh and John Fleming. *The Venetian Hours of Henry James, Whistler, and Sargent*, Boston: Little Brown and Co., 1991.

Kaplan, Justin. *Mr. Clemens and Mark Twain*, New York: Simon & Schuster, 1966.

Lewis, R.W.B. *Edith Wharton: A Biography*, New York: Harper & Row, 1975.

Lynes, Russell. *The Art-Makers: An Informal History of Painting, Sculpture and Architecture in Nineteenth-Century America*, New York: Dover, 1970.

Olson, Stanley. *John Singer Sargent: His Portrait*, London: Macmillan, 1986.

The American Renaissance: 1870–1917, The Brooklyn Museum, New York: Pantheon, 1979.

Index of Illustrations

◆ ◆ ◆

Edith Wharton, 1890, Miniature on ivory, 2¹/₂ x 2 inches, Collection of The New-York Historical Society, 1905.266

45 Giovanni Boldini
Consuelo Vanderbilt, Duchess of Marlborough and Her Son, Lord Ivor Spencer-Churchill, 1906, Oil on canvas, 87¹/₄ x 67 inches, The Metropolitan Museum of Art, Gift of Consuelo Vanderbilt Balsan, 1946, 47.71

46 John Singer Sargent
Egerton Leigh Winthrop, 1901, Oil on canvas, 63¹/₄ x 42¹/₄ inches, The Knickerbocker Club, New York, Photograph courtesy Adelson Galleries, Inc., New York

47 John Singer Sargent
Elizabeth Winthrop Chanler (Mrs. John Jay Chapman), 1893, Oil on canvas, 49³/₈ x 40¹/₂ inches, National Museum of American Art, Smithsonian Institution, Gift of Chanler A. Chapman, 1980.71

48 Henry Bacon
The Departure from New York Harbor, c. 1879, Oil on canvas, 19 x 27 inches, Collection of Eugene and Marcia Applebaum, Photograph courtesy Hirschl and Adler Galleries Inc., New York

50 Frederick Childe Hassam
Feeding Pigeons in the Piazza, c. 1883, Watercolor on paper, 20⁷/₈ x 12 inches, Private collection, Photograph courtesy Adelson Galleries, Inc., New York

51 John Singer Sargent
Cafe on the Riva degli Schiavoni, Venice, 1881, Watercolor, 9³/₄ x 13³/₄ inches, Private collection, Photograph courtesy Adelson Galleries, Inc., New York

52 Ralph Curtis
Drifting on the Lagoon, Venice, 1884, Oil on canvas, 25¹/₂ x 37¹/₂ inches, Private collection, Courtesy of Keny Galleries, Columbus, Ohio

54 Ralph Curtis and his mother, Ariana, in the Palazzo Barbaro, Venice, late 1880s, Photograph, Isabella Stewart Gardner Museum, Boston

55 John Singer Sargent
An Interior in Venice [artist's family at Palazzo Barbaro], 1899, Oil on canvas, 26 x 32⁷/₈ inches, The Royal Academy of Arts, London

56 Isabella Stewart Gardner and Gaillard Lapsley in a gondola in Venice, 1897, Photograph, Isabella Stewart Gardner Museum, Boston

57 John Singer Sargent
The Grand Canal, c. 1905–1910, Oil on canvas, 14 x 20 inches, Private Collection

59 John Singer Sargent
In the Luxembourg Gardens, 1879, Oil on canvas, 25¹/₂ x 36 inches, Philadelphia Museum of Art, The John G. Johnson Collection, J# 1080

61 Maxfield Parrish
Villa Chigi, Rome, 1903, Oil on paper, 28 x 18 inches, From Edith Wharton's *Italian Villas and Their Gardens*, Photograph courtesy the Archives of the American Illustrators Gallery, New York, © ARTShows and Products, Holderness, NH 03245, Authorized by the Maxfield Parrish Family Trust

62 Frederick Childe Hassam
A Spring Morning, c. 1890, Oil on canvas, 27¹/₂ x 20 inches, Photograph courtesy Berry-Hill Galleries, Inc., New York

65 Isabella Stewart Gardner, John Lowell Gardner, and guests at Beacon Street, 1891, Photograph (detail), Isabella Stewart Gardner Museum, Boston

66 Mary Stevenson Cassatt
Five O'Clock Tea, c. 1880, Oil on canvas, 25¹/₂ x 36¹/₂ inches, Museum of Fine Arts, Boston, M. Theresa B. Hopkins Fund, 42.178

69 Anders Zorn
The Waltz, 1893, Oil on canvas, 77 x 52¹/₂ inches, Courtesy of Biltmore Estate, Asheville, North Carolina

70 The Wedding of Florence Adele Sloane, 1895, Photograph, Collection of Louis Auchincloss

71 Charles Webster Hawthorne
The Trousseau, 1910, Oil on canvas mounted on wood, 40 x 40 inches, The Metropolitan Museum of Art, George A. Hearn Fund, 1911, 11.78

73 Alexandre Cabanal
Mrs. William Bayard Cutting, 1887, Oil on canvas, 39 x 52 inches, Museum of the City of New York, Gift of the daughters and grand-daughters of Mrs. William Bayard Cutting, 50.60.1

75 George Wesley Bellows
Tennis at Newport, 1919, Oil on canvas, 40 x 43¹/₄ inches, The Metropolitan Museum of Art, Bequest of Miss Adelaide Milton de Groot, 1967, 67.187.121

76 Julius L. Stewart
On the Yacht 'Namouna', Venice, 1890, Oil on canvas, 56 x 77 inches, Wadsworth Atheneum, Hartford, The Ella Gallup Sumner and Mary Catlin Sumner Collection

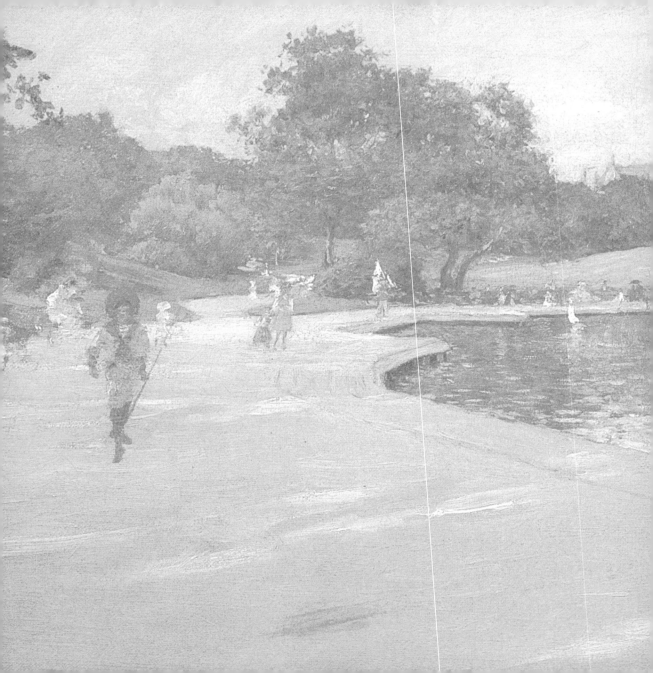